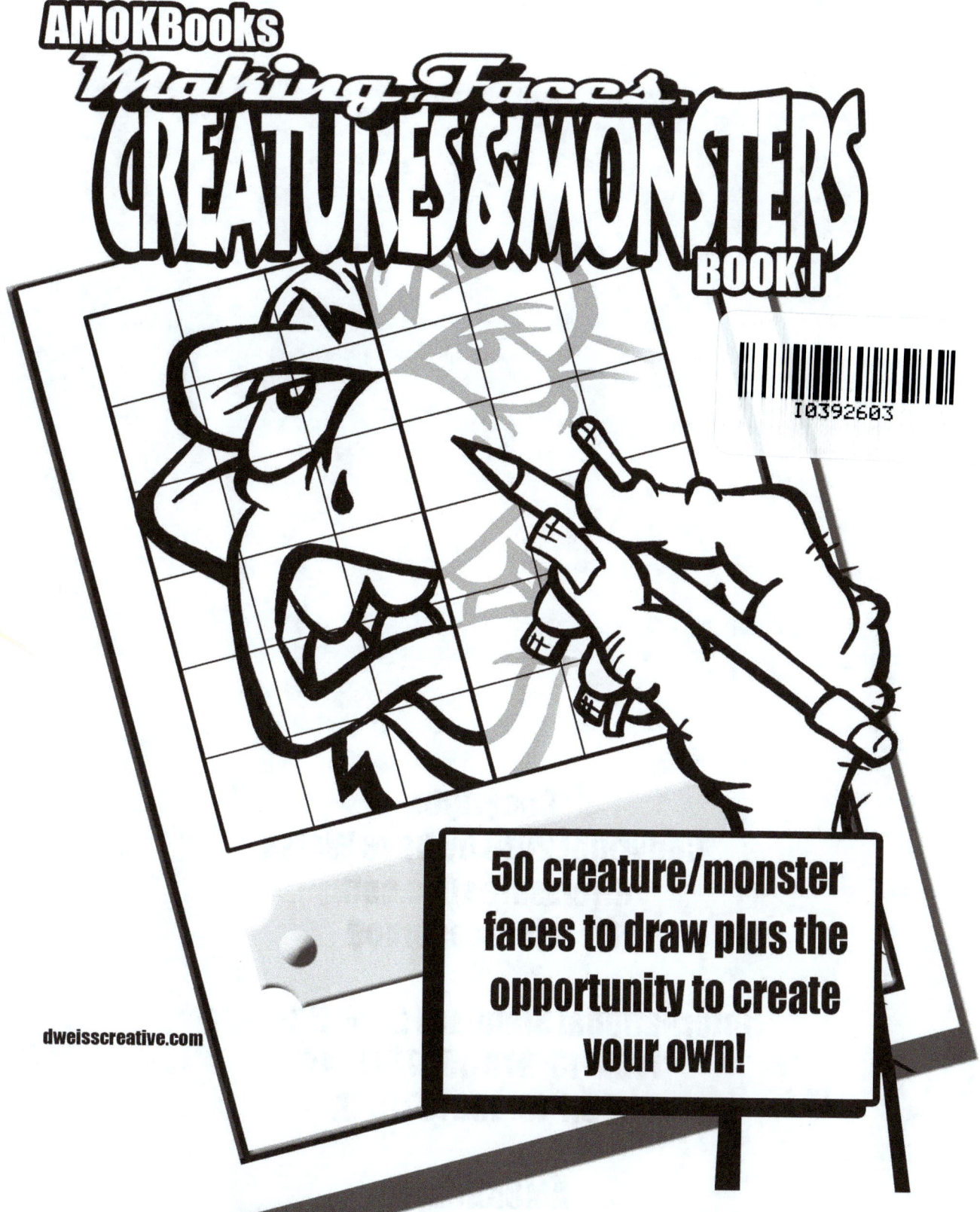

Copyright
Copyright 2016 by Dave Weiss
dweisscreative.com
All rights reserved

International Standard Book Number
ISBN-13: 978-1537377544
ISBN-10: 153737754X

AMOKBooks

Let's start by drawing Blobby

1. **Start in the center and duplicate what you see in the opposite square only backwards.**

2. **Work your way down the page and across the grid until the drawing is complete, copying as closely as you can.**

3. **When you finish, add color and decorate your picture.**

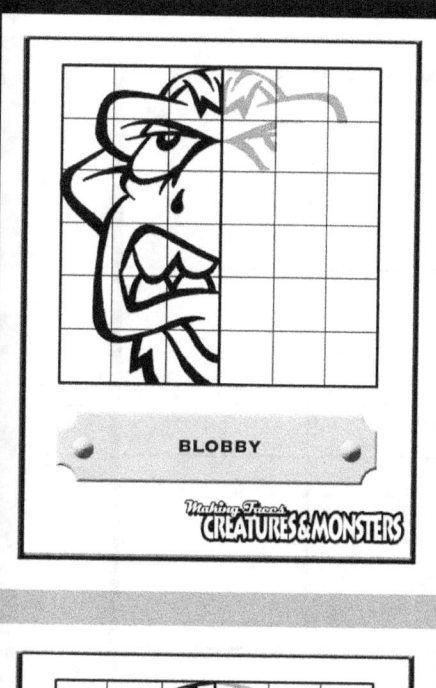
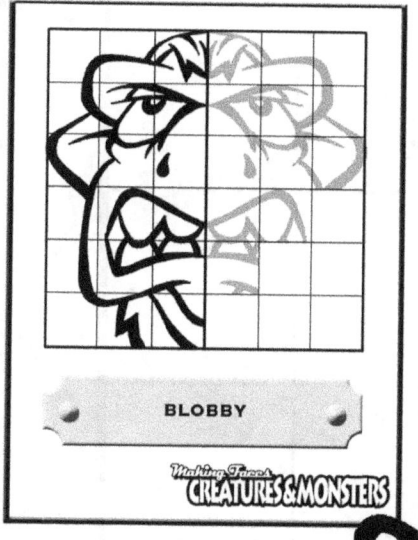
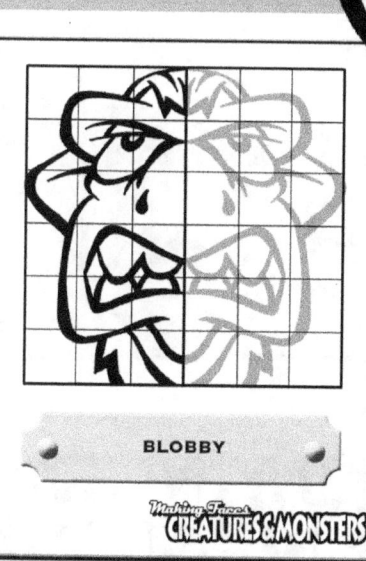

WORRIED WARD

SMILEY

GRUMPF

BONES

STACHE

CODFATHER

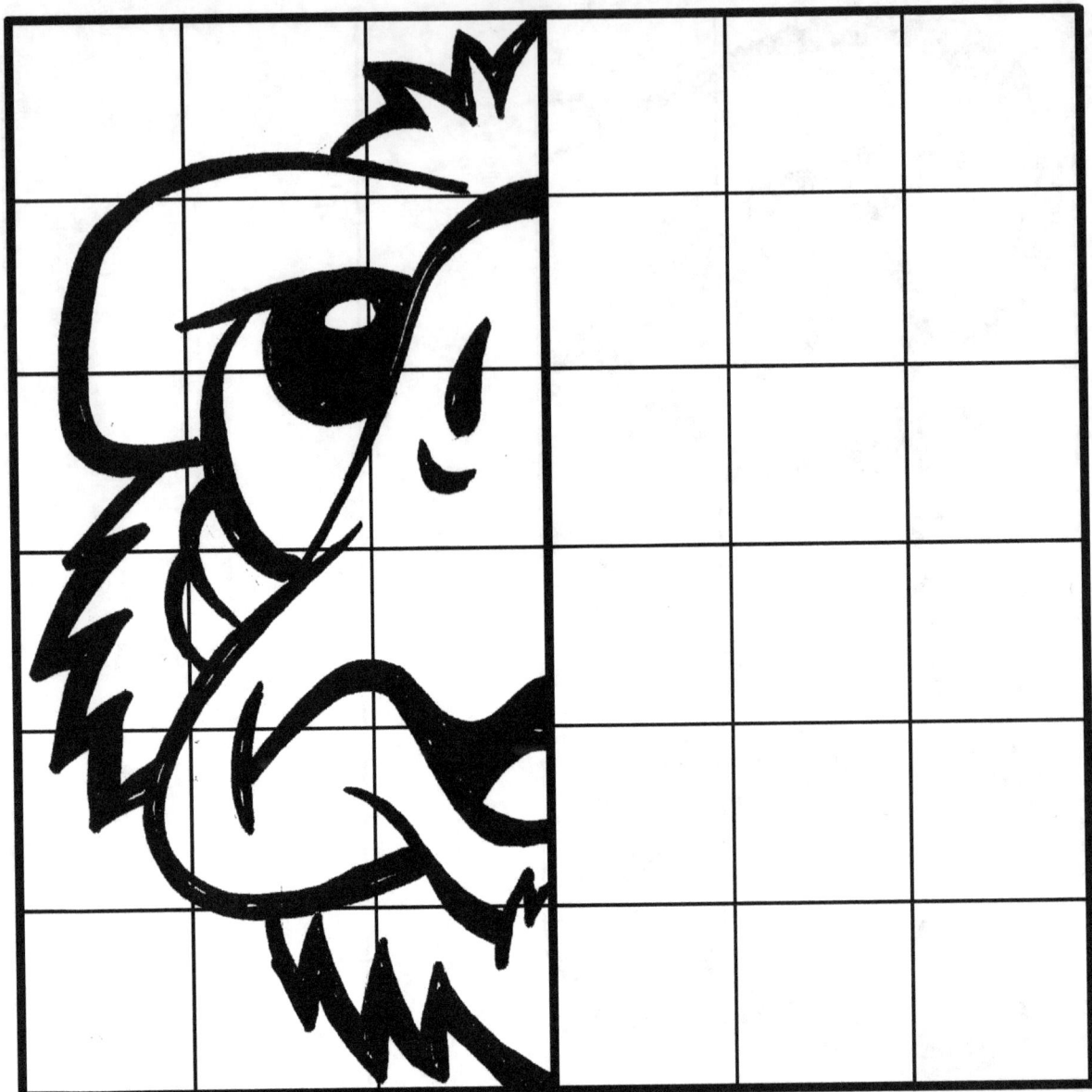

FURBALL

BEAKER

SEAMORE

SPIKE

BUGGSY

SI KLOPP

THEO

GRYPH

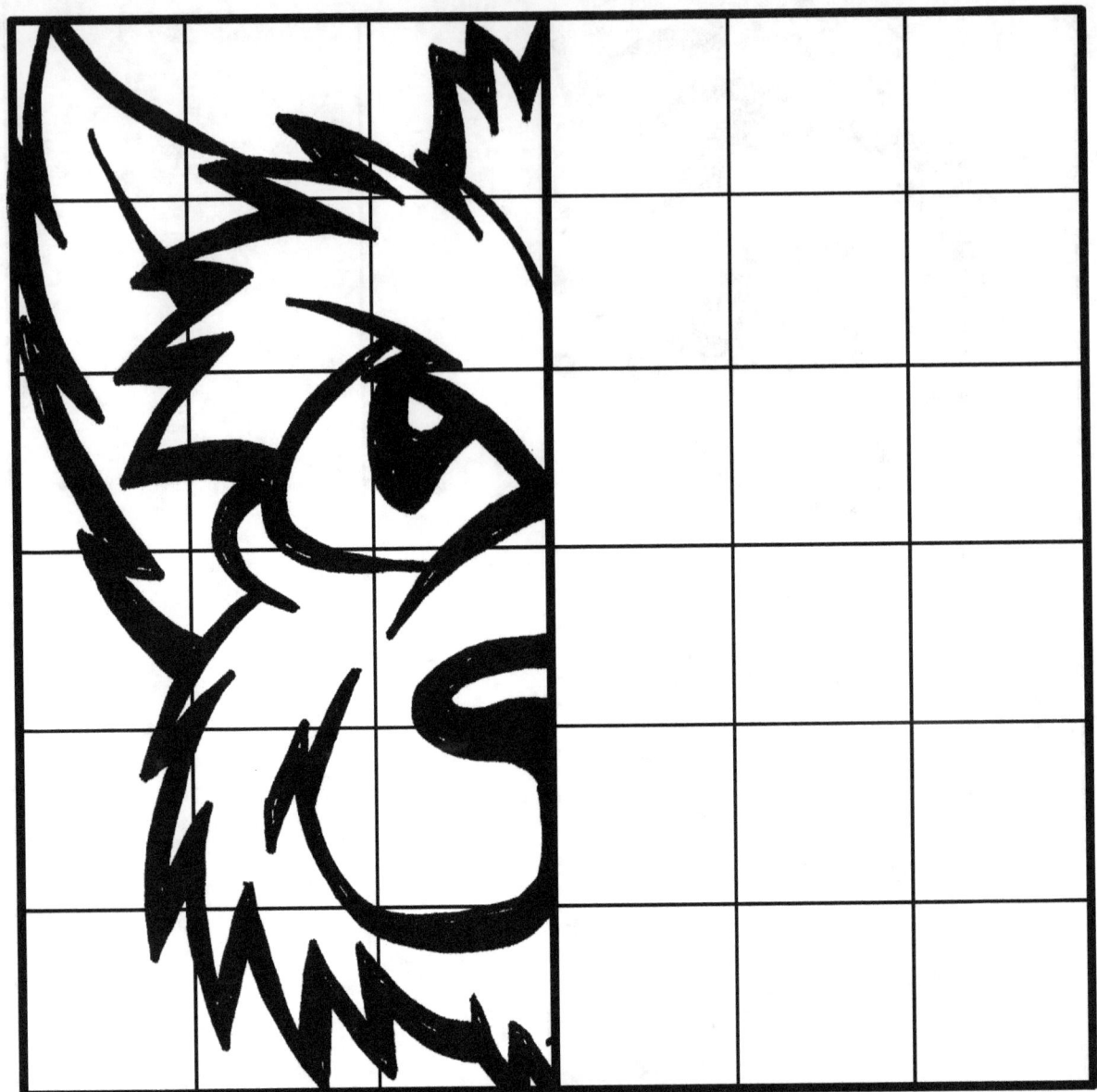

LYKAN

PHUZZI

WHININ' WILLY

WURM

DUCHAMP

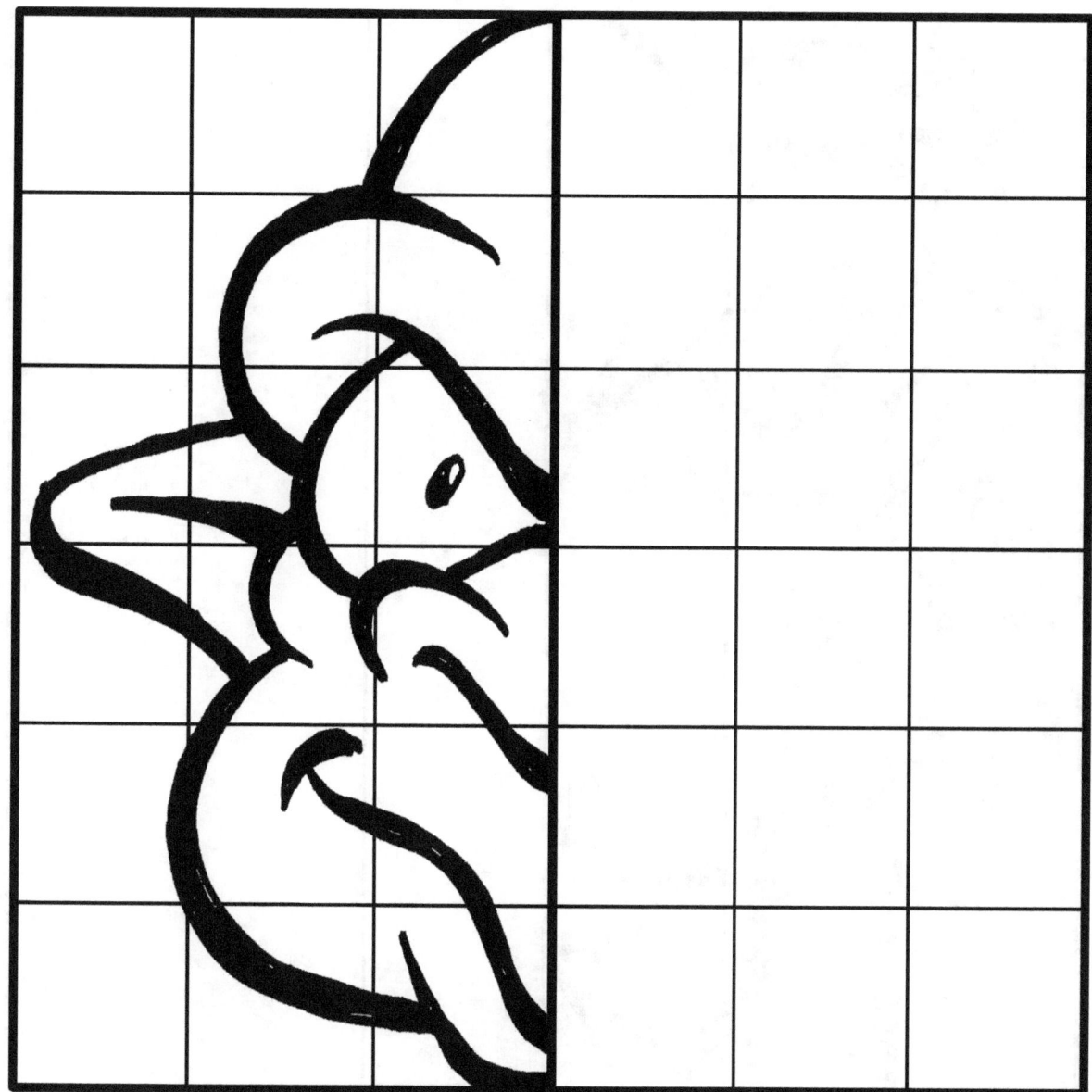

GREMM

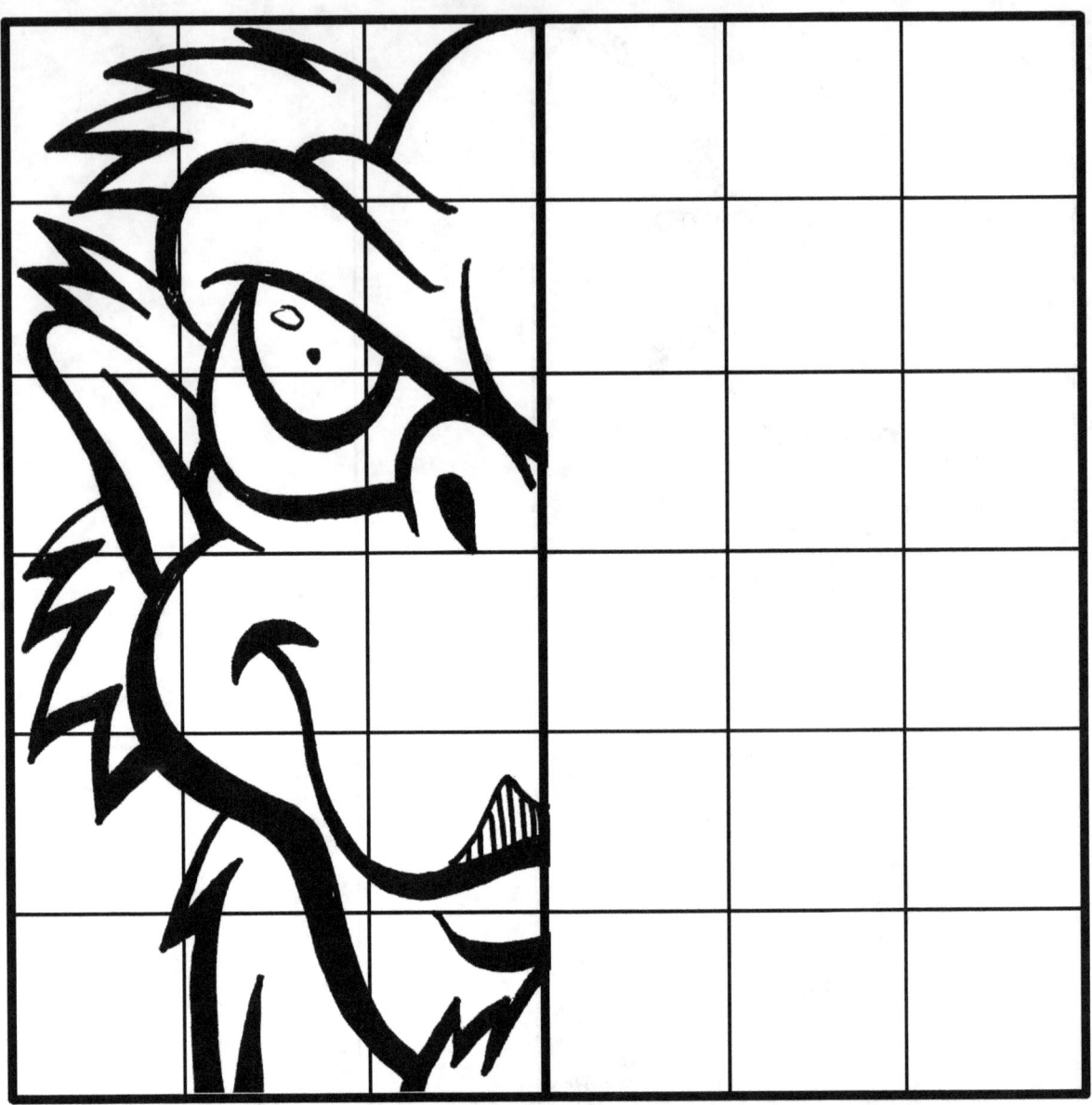

APEE

Making Faces
CREATURES & MONSTERS

FISHEYES

MAYHEM

PRIME 8

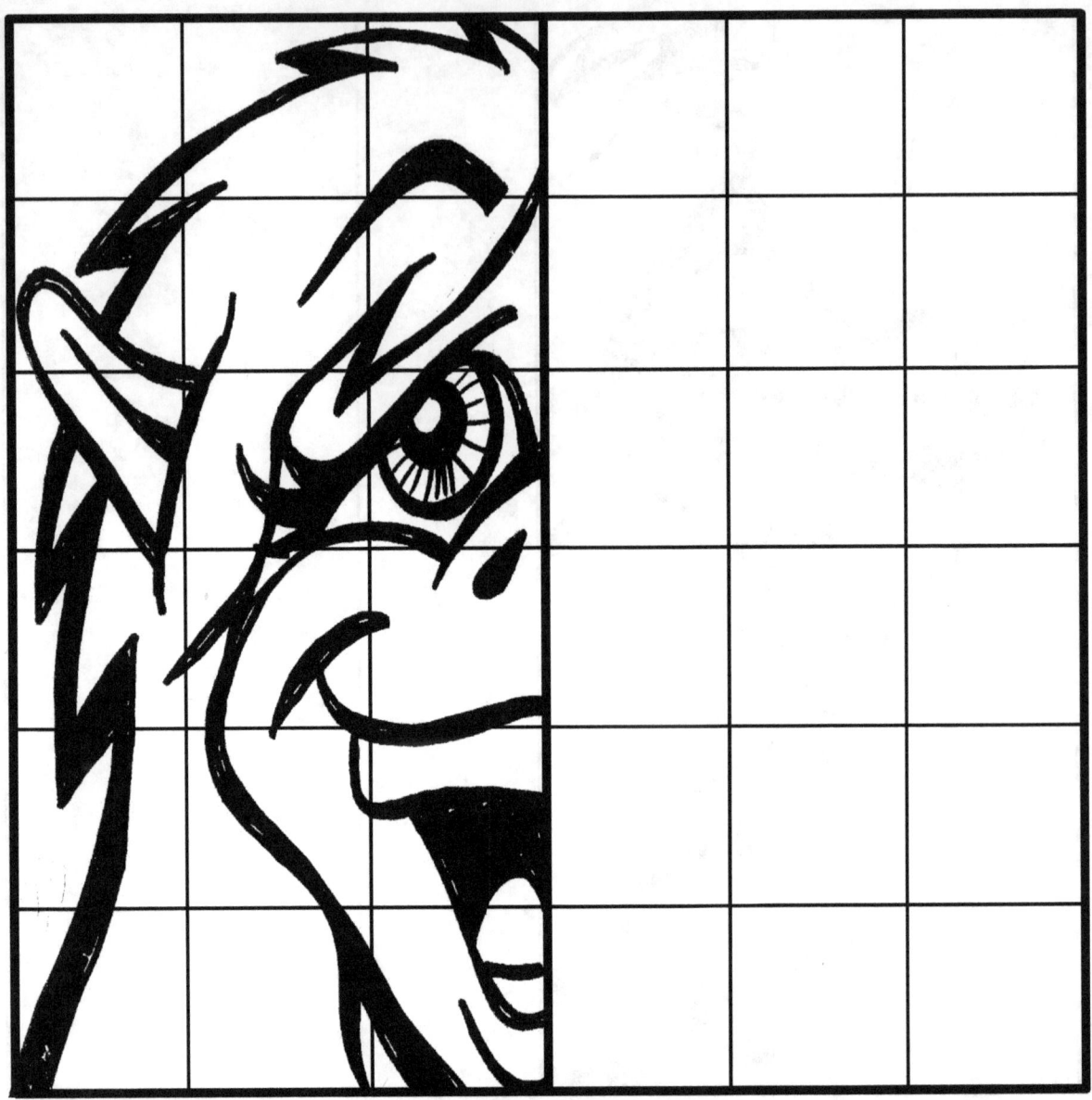

ELFIRA

Making Faces
CREATURES & MONSTERS

GIKI TIKI

MURRARR

TROLLAND

RAJ-RAJ

GILGAMESS

FANG

AIRFOX

CREEPY CREEP

BRAINS & BROWS

SPACE CLOWN

NOSY-FERATU

GATORO

CHANNEL KATT

STARMAN

TARSIER

HONU

HOWIE

GOOF

HOGGY

HAPPY GILOOKY

SHIFTY

TOTEM TORTUGA

DRECK

FEARFUL FERGUS

BLOBBY

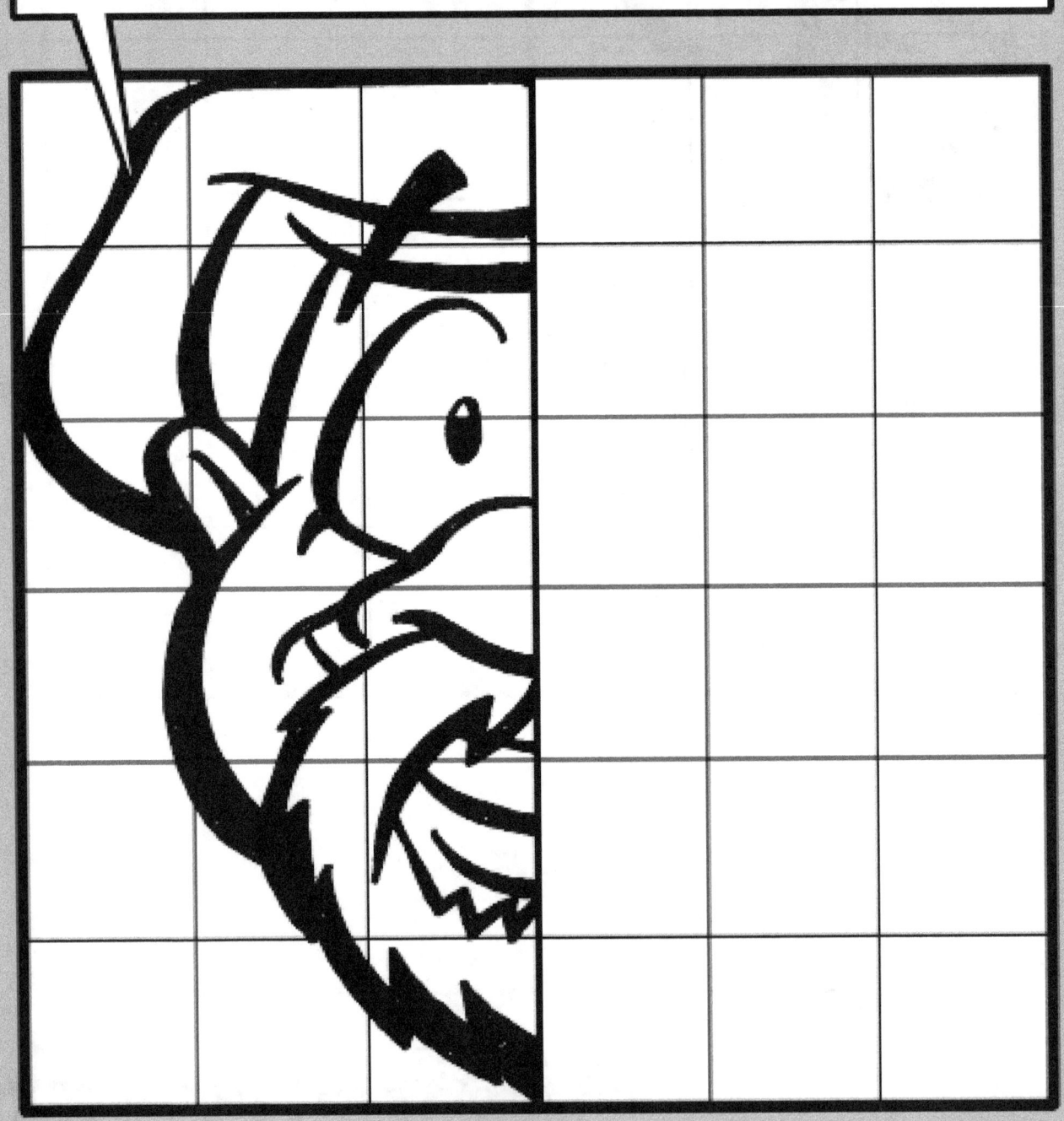

For more resources to build your creativity go to dweisscreative.com